ABANDONED
AND HISTORIC
— LOS —
ANGELES
NEON AND BEYOND

JASON HORTON

AMERICA
THROUGH TIME®
ADDING COLOR TO AMERICAN HISTORY

For Quincy

America Through Time is an imprint of Fonthill Media LLC
www.through-time.com
office@through-time.com

Published by Arcadia Publishing by arrangement with Fonthill Media LLC
For all general information, please contact Arcadia Publishing:
Telephone: 843-853-2070
Fax: 843-853-0044
E-mail: sales@arcadiapublishing.com
For customer service and orders:
Toll-Free 1-888-313-2665

www.arcadiapublishing.com

First published 2020

ISBN 978-1-63499-255-8

Typeset in Trade Gothic
Printed and bound in England

Photographs by Jason Horton unless otherwise noted.

CONTENTS

ABOUT THE AUTHOR

JASON HORTON is a New York native who has lived in Los Angeles for almost fifteen years. He is a writer/comedian seen on Comedy Central, TruTV, and the feature film, *The Thinning: New World Order*. Jason also hosts the podcasts *Ghost Town* and *Strange Year*. He is obsessed with filming locations, historical landmarks, abandoned places, and of course, Los Angeles.

FOREWORD

What does it mean to be "from" Los Angeles? Must you have lived here a certain number of years? Work in the movie industry? Should you be from the city proper, versus one of its many outlying jurisdictions? Or, are you only a native if you were born here, set apart from the many transplants who pack up their cars and covered wagons to reimagine a life out west? This is a question that isn't easily answered.

I've had quite a few jobs during my own twelve-year residency in Los Angeles; one of the more interesting ones was as a private tour guide to the city. In a lone Toyota Sienna van, I would pick tourists up at LAX or the Santa Monica Pier or the Roosevelt Hotel in Hollywood. My passengers came from all over the world and we would spend the day seeing whatever they wanted. The range of excitement, knowledge, and interests varied greatly within these groups: in a week, I'd be driving a gaggle of Iowan Mötley Crüe fans down the Sunset Strip, showing a quiet family from Singapore LA's crown architectural treasures, or feverishly Googling the location of the studio in *Dance Moms* for a couple of overzealous Australian reality television fans (it's in Brentwood, by the way). It was never boring, and I learned so much through tour guiding: my own perception of LA became ever-expanding, revealing more and more to me about humanity, belonging, history, and truly what it means to be "from" LA.

I sincerely believe that if you connect to my amazing city, you can call it home. Through a memory, an interest, a prior visit, an address, or a familial tie, the beauty of LA is the city's multi-faceted relationship with whomever is drawn to it. I hope you claim a bit of your own nativity in Jason Horton's intriguing and memorable collection of essays and photographs, a tool to explore and enjoy the city's undeniable richness.

REBECCA LEIB
Comedian, Writer, Producer, Cultural Journalist
and Echo Park Neighborhood Councilperson

ACKNOWLEDGMENTS

THANK YOU FOR THE WORDS:

Josie Cotton
Katie Featherston
Andrew Kline
Eric Komst
Rebecca Leib
Molly McAleer
Terra Newell
Danny Boy O'Connor
Dan O'Mahony
Carlos Ramirez
Greg Sestero
Kristina Wong

THANK YOU FOR THE PHOTOS:

Alixan Gorman / @valley_haunts
Glenda Smith / @signmonger
Josh McNair / @californiathroughmylens
Stephen Saffarewich / @stephensaff
Rebecca Leib / @rebeccaleib

*Thank you to the city of Los Angeles, Los Angeles County,
and the great state of California.*

INTRODUCTION

I love living in Los Angeles. This city is flawed. It needs work. I know that. Now that I've gotten the obvious out of the way, I can continue to sing the praises of this amazing place. With over 10 million residents and almost 50 million people visiting every year, there must be something to what I am saying. There are those that say—likely, mindlessly repeat—that LA doesn't have any culture. Wrong. Beyond being the entertainment capital, LA has neighborhoods, areas, and locales that are culture defining. From Downtown to the Valley, from the Westside to Hollywood, the Eastside and back again, the structural makeup of LA deserves to be celebrated.

These photos depict places that I have passed once, twice, or a thousand times. For whatever reason, I wanted to capture it and hold on to it. I'm not sure why I love an abandoned mall, neon sign, or historic landmark. Maybe it's because, in a time where places are decimated post haste for something more profitable and modern, they survive. As much as I wish the city could be one big national landmark, that's not realistic: LA's history and memories are holding on by a thread. I try to preserve them one of the only ways I know how: these words and iconic photos.

I love hearing stories and anecdotes about Los Angeles. Whether it was something that happened five minutes or fifty years ago, I'm interested. With that said, I used this opportunity to have people I find way more interesting than myself to contribute their story, their anecdote, about LA.

LA is vast. There are an endless amount of photos and stories that couldn't possibly fit in one book. However, I think we are off to a pretty good start. When anyone asks me, "If you could live anywhere in the world, where would you live?", I tell them I already live there.

JASON HORTON

1

VINTAGE

Los Angeles is home to America's first neon signs: two illuminated "Packard" ads, installed in the city's bustling, post-war downtown. Even today, you don't have to look too long or too far for these majestic reminders of LA history. The familiar and flickering signs of shops, stores, restaurants, and theatres are like a neon-laden timeline of the city. Feel free to spend the night at a classic LA area motel, color TV included.

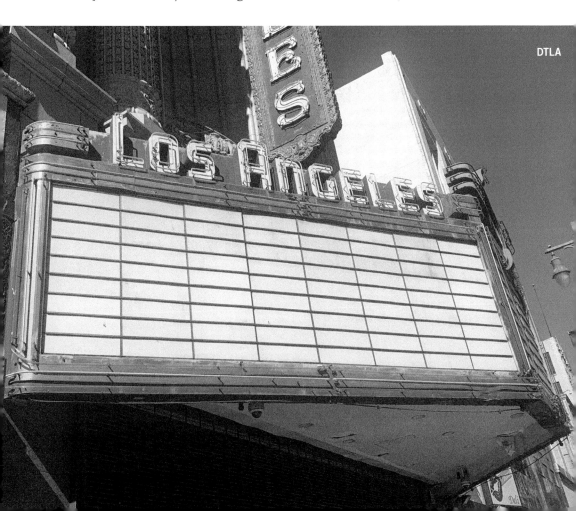

DTLA

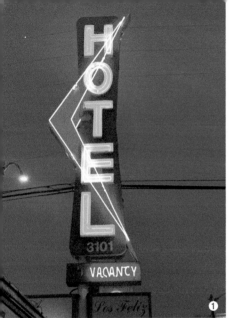

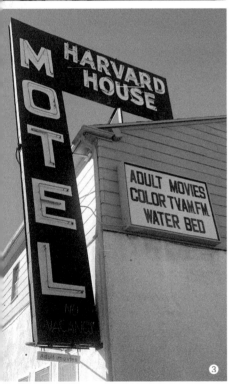

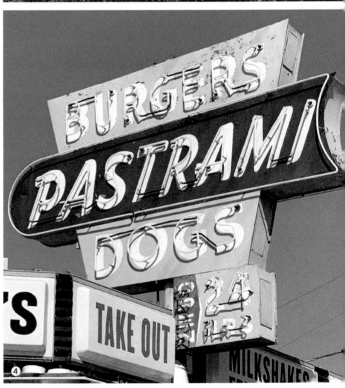

❶-❷ Atwater Village ❸ East Hollywood ❹ West Adams [*Glenda Smith*]

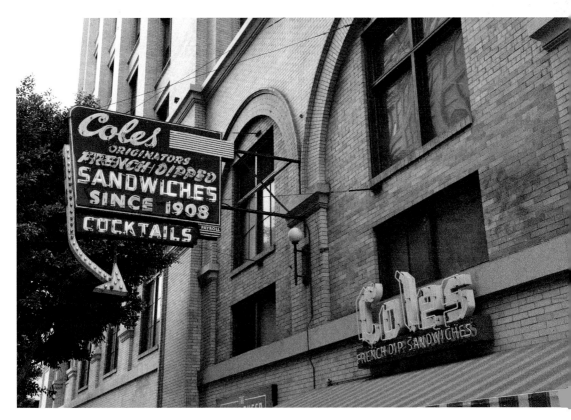

DTLA [*Steve Cukrov*]

I started out living in West Hollywood in the late 90s. Being from the East Bay up Northern California, it took me a while to adjust. I finally found a city that spoke to me with South Pasadena. Tree lined streets, craftsman homes designed by Greene & Greene and Frank Lloyd Wright—it felt like home. The entire place shuts down every Thursday evening for a farmer's market with live music. You can find families out with their kids, a great local library, and movie rental house. The entire city celebrates Halloween and Christmas unlike any community in Los Angeles.

The creative vibe burns bright in South Pasadena. Sure enough, several of my favorite films were shot in the area: *Back to the Future*, *Halloween*, *Mad Men*, *Pee Wee's Big Adventure*, *La La Land*, *Catch Me if You Can*, and *Father of the Bride*, among others.

GREG SESTERO
Author/Actor (*The Disaster Artist*, *The Room*)

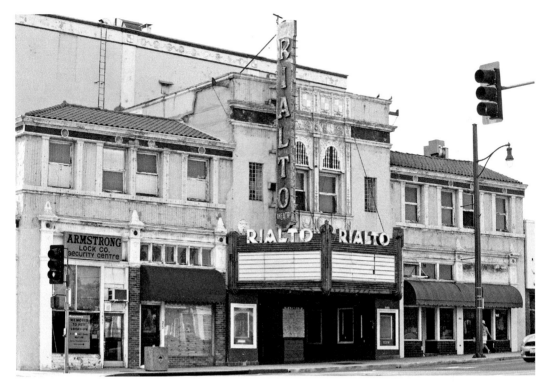

Pasadena [*Philip Pilosian*]

Van Nuys [*Alixan Gorman*]

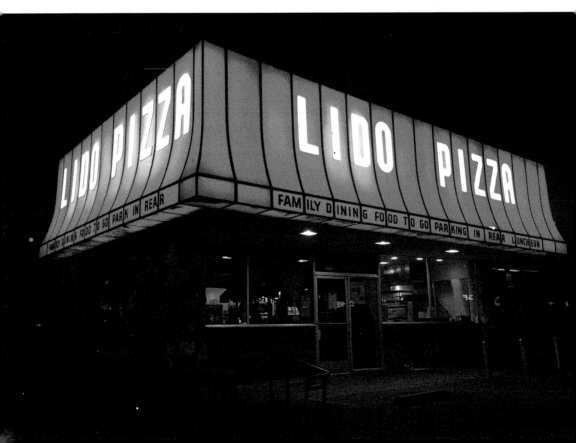

❶ Hollywood [*Glenda Smith*]

❷ Granada Hills [*Alixan Gorman*]

❸ DTLA

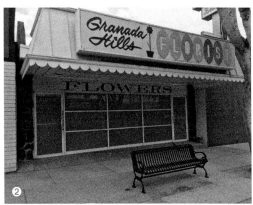

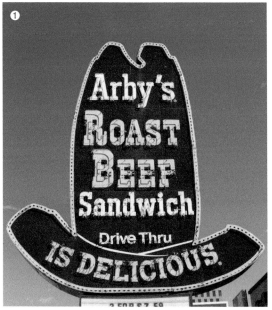

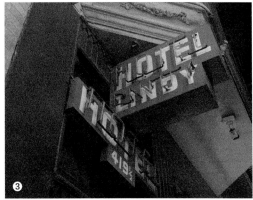

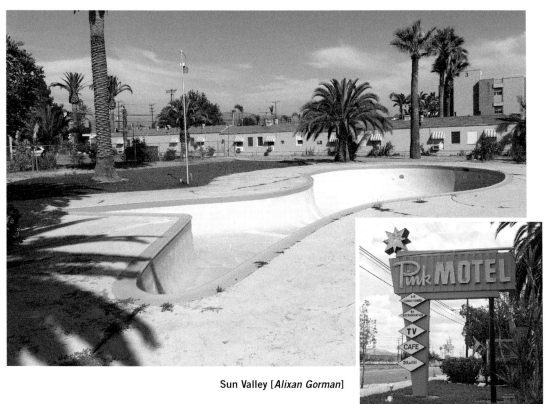

Sun Valley [*Alixan Gorman*]

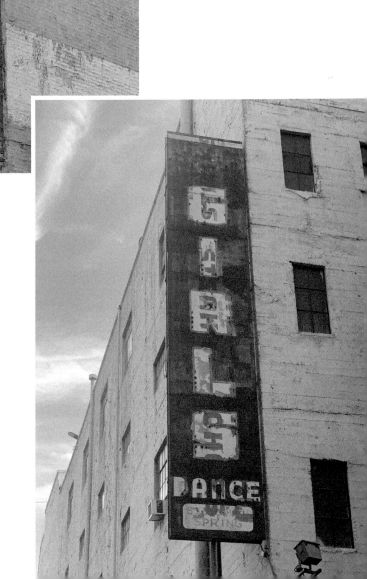

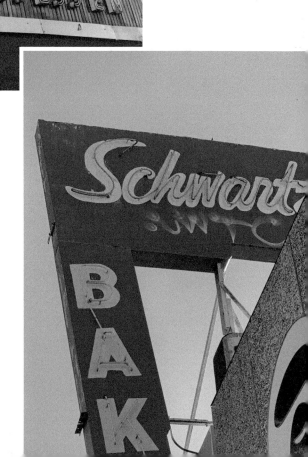

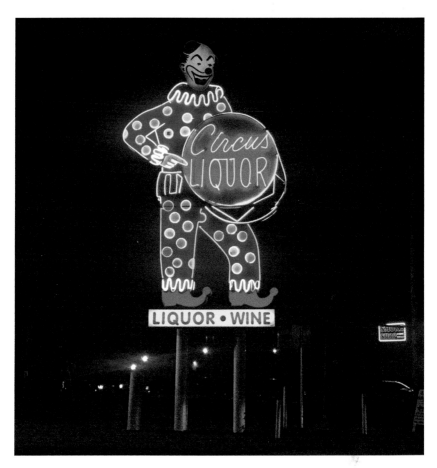

North Hollywood [*Alixan Gorman*]

❶ Granada Hills [*Alixan Gorman*] ❷ Hollywood [*Alex Millauer*] ❸ Van Nuys [*Alixan Gorman*]

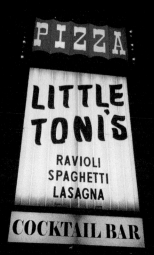

North Hollywood [*Alixan Gorman*]

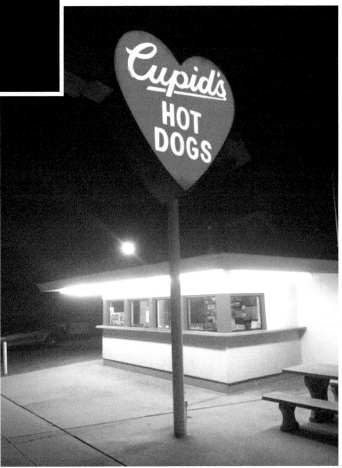

Northridge [*Alixan Gorman*]

Most people in LA tell me that LA people are the worst, but why do they still live in LA?

TERRA NEWELL
Author, Podcaster (*Dirty John, Time Out With Terra*)

DTLA

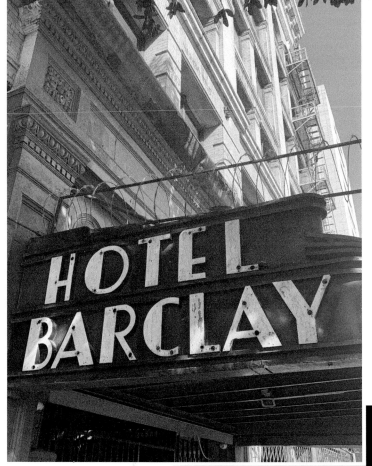

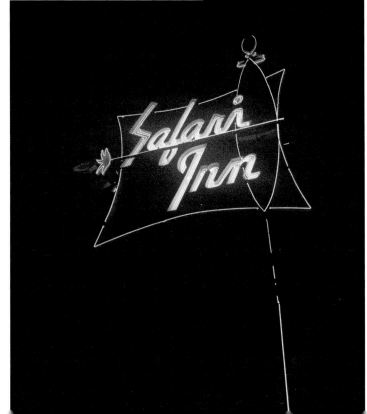

Burbank [*Alixan Gorman*]

Burbank [*Alixan Gorman*]

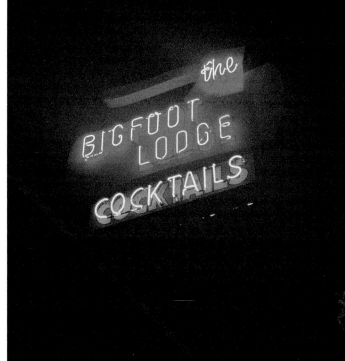

Atwater Village

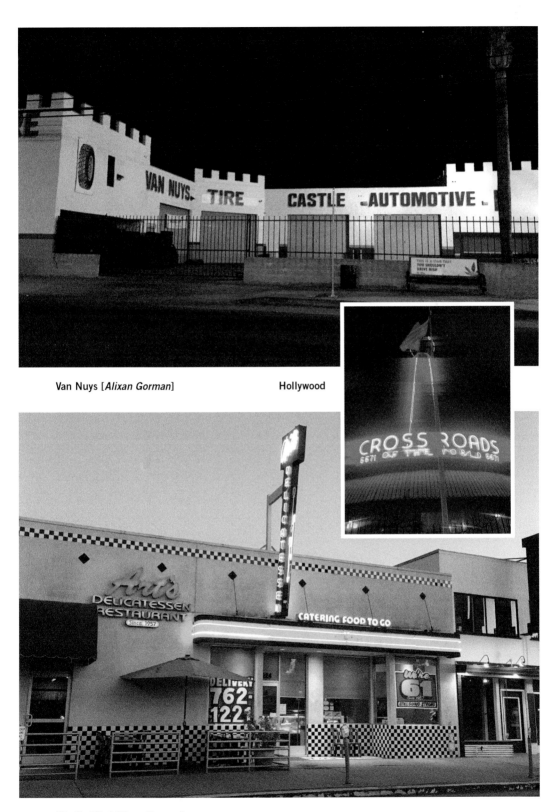

Van Nuys [*Alixan Gorman*]

Hollywood

Studio City [*Alixan Gorman*]

Glendale

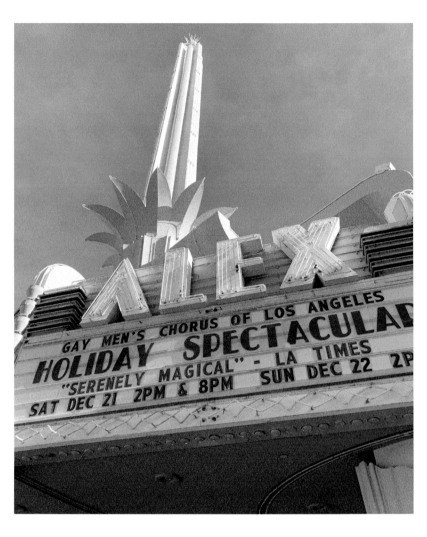

North Hills [*Alixan Gorman*]

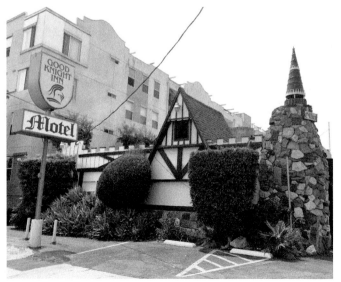

❶ Burbank [*Alixan Gorman*]

❷ Eagle Rock [*Marie Dolphin*]

❸ Van Nuys [*Alixan Gorman*]

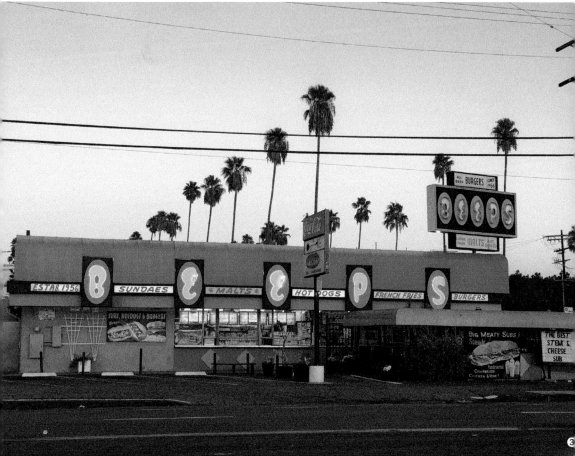

❶ DTLA

❷ Hollywood [*Glenda Smith*]

❸ Hollywood [*Elliott Cowand, Jr.*]

Growing up, what I knew about Hollywood came almost exclusively from television, specifically the season of *I Love Lucy* where the Ricardos and Mertzs were living in some swank hotel while Ricky filmed a movie. In 2013, I was suddenly working smack dab in the middle of Tinseltown as I ran a shithole bar at the intersection of Hollywood Blvd and Las Palmas Ave. Turns out the Chinese Theater, Musso & Frank, the Beverly Hills Hotel, all of it, they aint in black and white, they ain't clean, and Rock Hudson or Bill Holden or whoever the hell it was aint makin' eyes at anybody between the potted plants.

Old Hollywood ain't what it was supposed to be. It's filthy. It aint safe after dark. Chewbacca wanders the sidewalk in a suit missing way too much fur. On his heels, Ironman poses for pics in loud and clunky plastic. They do well from what I can see, but the Batman and Spidey that I encounter on Hollywood Blvd. could both stand to mix in a salad. Lucy, you got some 'splaining to do.

DAN O'MAHONY
Author, Musician
(*No For An Answer, 411, Shiners Club*)

Hollywood
[*Stephan Saffarewich*]

Westchester
[*Glenda Smith*]

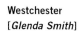

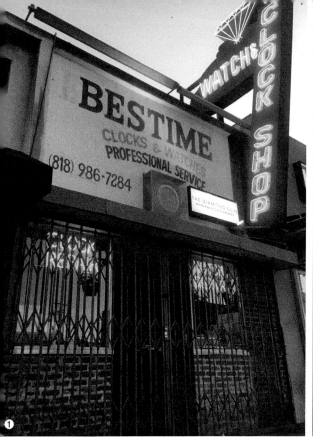

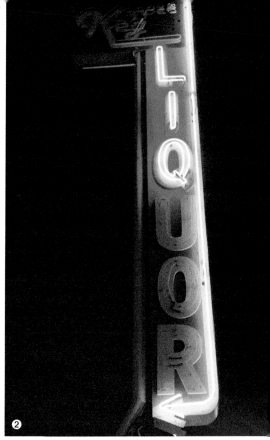

❶ Sherman Oaks [*Alixan Gorman*]

❷ Atwater Village

❸ DTLA

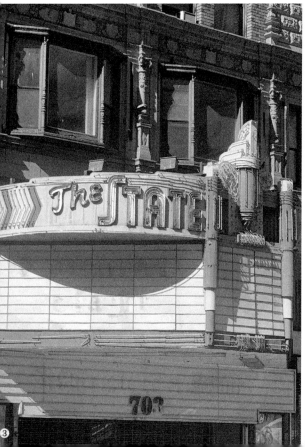

❹ Santa Monica Pier

❺ North Hollywood [*Alixan Gorman*]

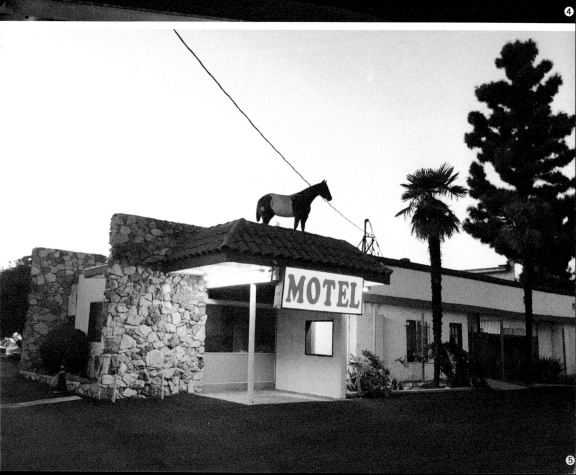

SANTA MONICA ★ YACHT HARBOR ★ SPORT FISHING ★ BOATING cafes

④

MOTEL

⑤

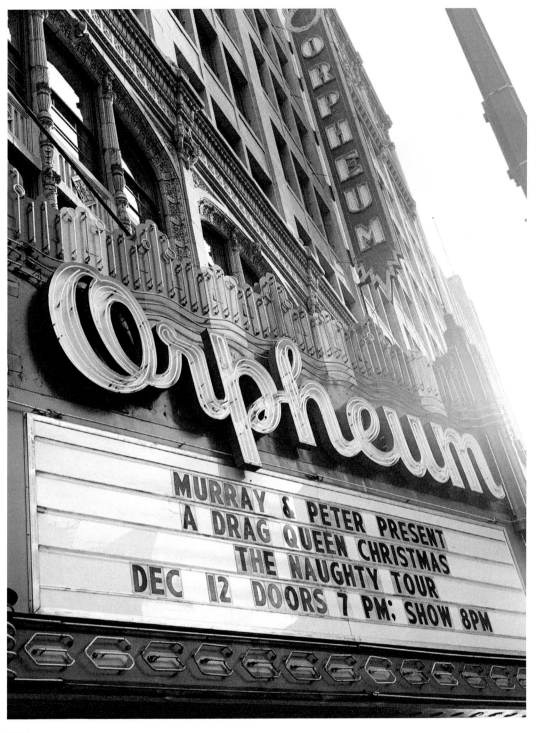

DTLA

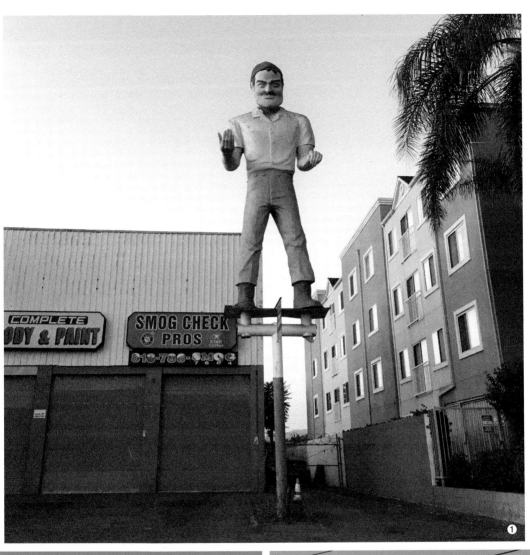

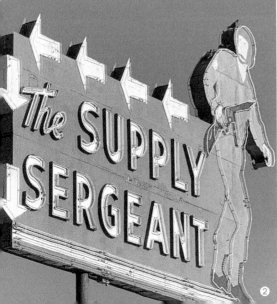

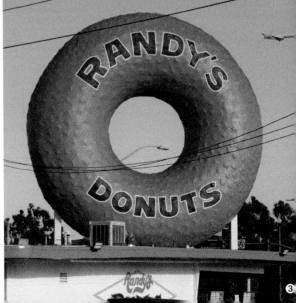

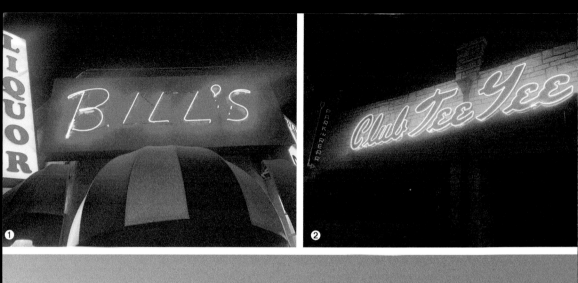

❶ Atwater Village ❷ Atwater Village ❸ North Hills [*Alixan Gorman*]

You would be hard pressed to find someone who didn't like, or even love, Robin Williams. I had my mind set on moving to California from New York. So much so, that I didn't ask too many people their thoughts on the subject. However, one of the people I did ask, was Robin Williams.

We were at the same comic and vintage toy store in NYC in early 2001. He seemed affable, and I just wanted to meet him. I introduced myself and told him I was thinking of moving to Los Angeles, because I loved comedy and was pretty much over the snow and humidity of New York. He was really nice, brief, and encouraging.

Fast forward to what I believe was 2009, or maybe 2010. Robin Williams notoriously would drop in at the improv comedy theatres in LA and perform. One night I was headed backstage at the Upright Citizens Brigade Theatre, to wait in this little hallway behind the green room, and next to what I guess would be the dressing room. This was a standard area to wait to meet other people, rehearse, and so on. I had gotten there a little early to attempt to memorize lines for a sketch we were doing that night. The difference was, on this night, Robin Williams was there. I mean, he was just leaning up against the wall, like he wasn't Robin Williams or something. As if he was a regular boring person like the rest of us. He was the same sweet, kind person I remembered from years before.

We chatted briefly, and I made it a point not to take up too much of his time or energy. I told him how we met previously, and how encouraging he was, and he was glad to see I followed through. I was always hoping to meet him again. I would perhaps have asked him what I should do next. Whatever that is, I guess I'm already doing it.

JASON HORTON

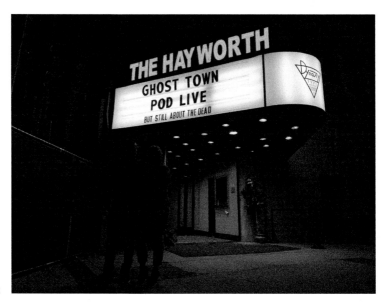

MacArthur Park

2
ABANDONED

When the bright lights dim, catch a glimpse of LA's abandoned, vacant, gritty and faded landscape. You may have to turn a few dark corners to find some of the more obscure gems, but for the most part, the Los Angeles of yesterday is hidden in plain sight.

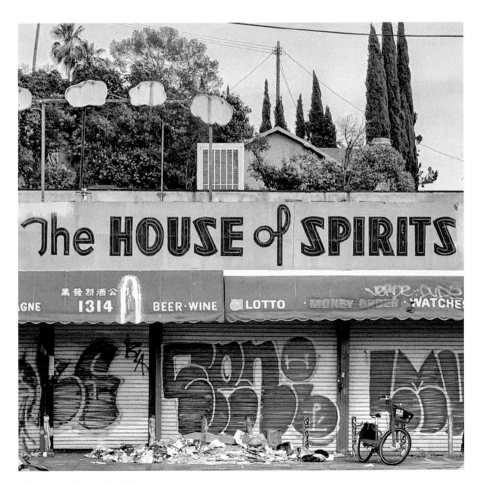

Echo Park [*Glenda Smith*]

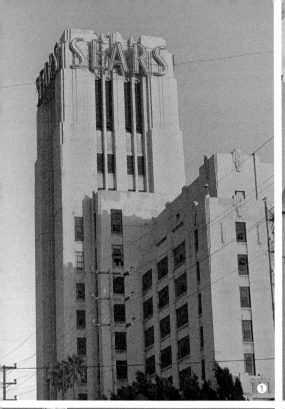

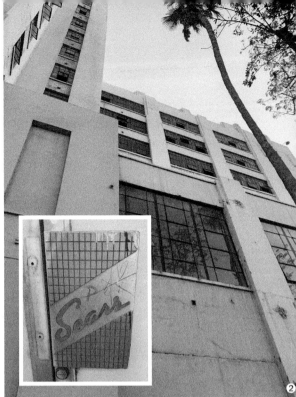

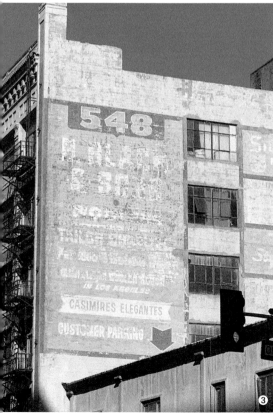

❶-❷ Boyle Heights ❸-❹ DTLA

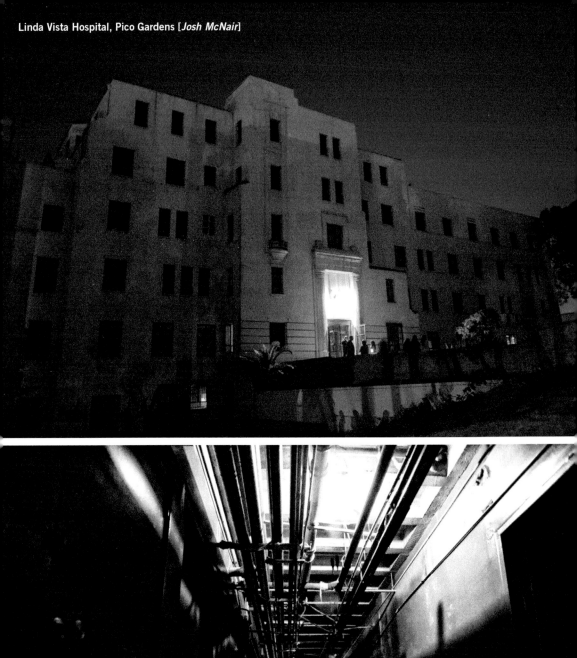

Linda Vista Hospital, Pico Gardens [*Josh McNair*]

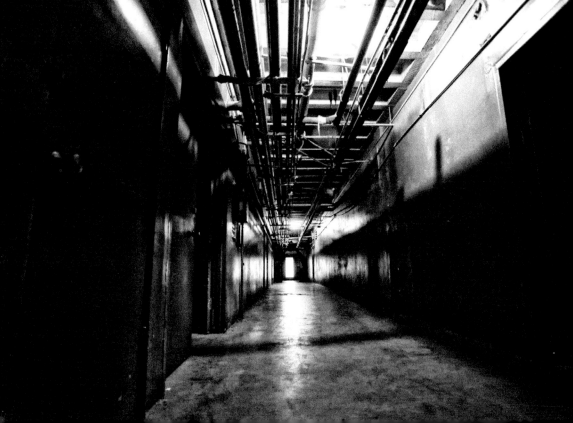

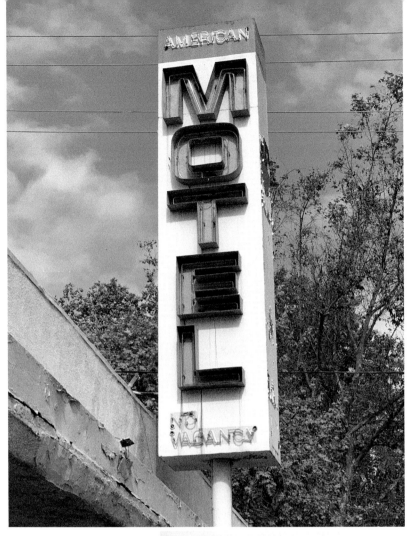

Glendale

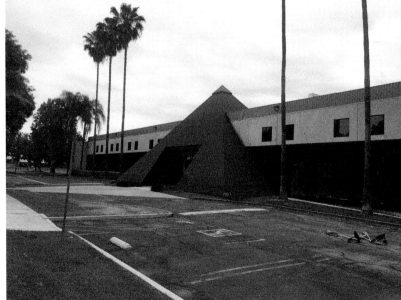

Woodland Hills
[*Alixan Gorman*]

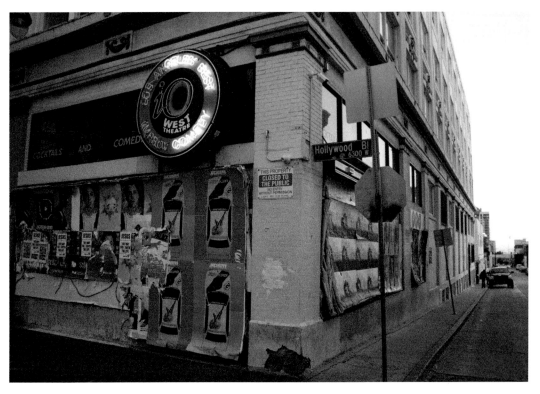

Hollywood [*Stephen Saffarewich*]

San Fernando [*Alixan Gorman*]

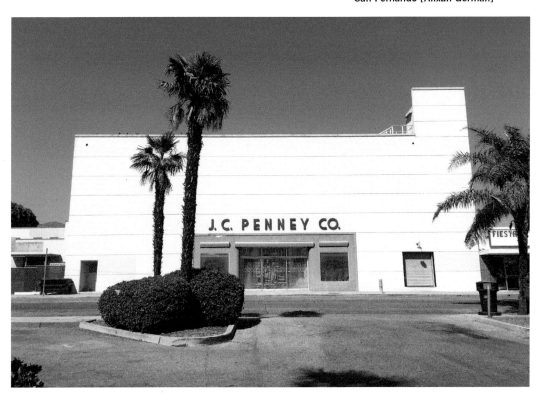

I was living in a studio apartment at 8th and St Andrew. Twenty-five years old. I had graduated college into the birth of the Great Recession. I was directionless and under the impression that it was normal to write eleven blog posts at the price of seven dollars each "for a living." It's unbelievable that this happened at the end of my frontal lobe developing. I always think about my poor frontal lobe showing up to the party and seeing the mess I'd created without it.

It was a bad scene before the bedbugs came. My electric was always getting cut. I'd take freezing cold showers for a week because the gas was turned off. Any electronic I owned was essential to my career and if it broke, it could very well cost me my jobs. It wasn't hell on earth, it was worse. Economic purgatory. This is not an uncommon scenario for millions of Americans, but I had a terrible case of the "fragile whites" and didn't expect my life to so perfectly align with the lyrics to the theme song from *Friends*. All of this is to say that the whole Los Angeles thing wasn't really going as planned. I knew it was going to be hard, but I didn't know it would make me watch movies like *Reality Bites* and think, "What are these psychopaths complaining about? They have a couch."

Around this time, I started listening to this young female MC out of Queens named Nicki Minaj. My friend Blaire had become hip to her and passed on her music to me. I played it all the time. Non-stop. I celebrated her the way I celebrated Hansen when I was thirteen. I would preach about her to everybody. She was tough, her words had bite. She was sexy and girly and especially funny. And she worked hard.

At the peak of my fandom, a friend pulled off a once-in-a-lifetime favor. His friend was a big-time photographer. He'd recently done a magazine spread for Nicki and she and her team liked it so much that they hired him to shoot the cover of her first album, Pink Friday. And he was going to get me into that shoot.

Security was tight. This was an artist on the verge of breaking into the mainstream with her own album, but she was quite famous by this time. She'd been featuring on a lot of big radio hits and had ripped America's face off on Kanye's track, "Monster." She was signed to Young Money Entertainment and because Wayne was in jail at the time of the shoot, Diddy made visits throughout the day and kept an eye over everything. That has always been something that's stuck with me. Heavy "big brother's best friend" vibes.

But I was not Diddy. I was a twenty-five-year-old, barely employed blogger who slept on her floor. With no real job for me on set, they decided to cast me as the photographer's life coach.

It was my job for the day to stand near the photographer and occasionally say kind words to him or act as a gopher when needed. I was right there for all of it. Every minute that she was shooting, I stood right there and watched. She was tiny and spoke softly and seemed shy. Possibly because standing next to her photographer was a woman in crisis wearing a lime green sweater with a three-inch hole in the right armpit.

At the end of the shoot, the photographer granted me and the other people on set permission to ask her for a photo. My moment was here. She seemed absolutely exhausted but still stayed and took photos with each of us. When she stepped toward me, she wanted to stand on the left, which was nerve-wracking because the right side of my face was hit by a train the moment I came out of my mother's body. It's a mess. We posed for the picture and while she looked ready for Hollywood, I looked like I should move home. Right as she was about to leave, I called to her, "Nicki, I'm so sorry, is there any way we could take another picture? I look insane."

She looked at me with eyes that said, "You are naughty, and you know it." I choose to think that she was somewhat charmed by my audacity because I can't move forward with any of the alternative reactions. The second one was good enough to post to Tumblr, which mattered a lot because my priorities were grim and idiotic, if I'm being kind.

It was moments of magic like that that helped me realize this city can take a lot out of you, but when it gives back, it gives back big. Like "living all of your wildest childhood daydreams" big. Between that and the weather, it's the only place to be.

MOLLY MCALEER

Writer, Author, Podcaster

(*2 Broke Girls*, Hello Giggles Co-Founder,

Mother May I Sleep With Podcast)

❶-❷ DTLA
❸ Glendale
❹ DTLA

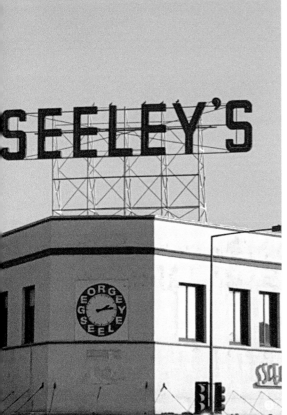

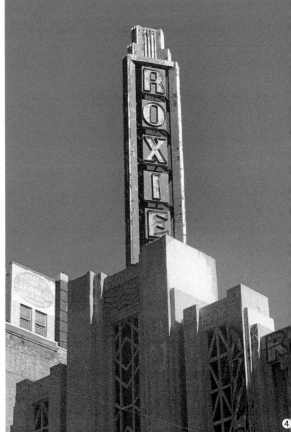

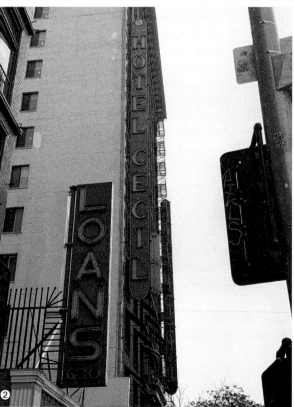

❶ Hollywood [*Stephen Saffarewich*]　❷ DTLA　❸ Fairfax District

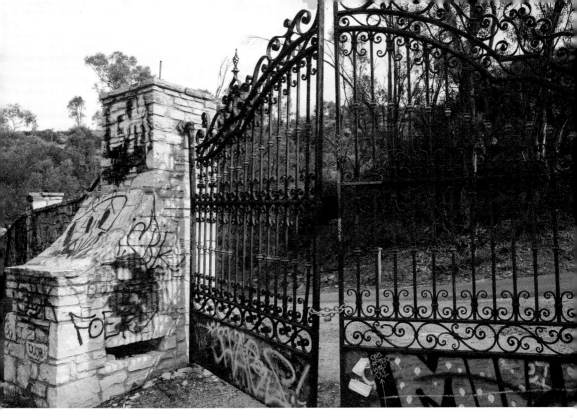

Murphy Ranch, Pacific Palisades [*Josh McNair*]

Pacific Palasades [*Rebecca Leib*]

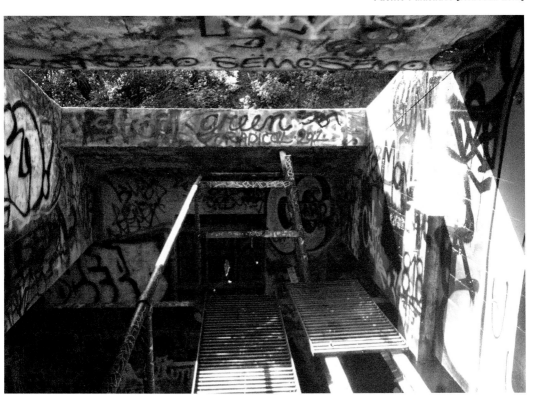

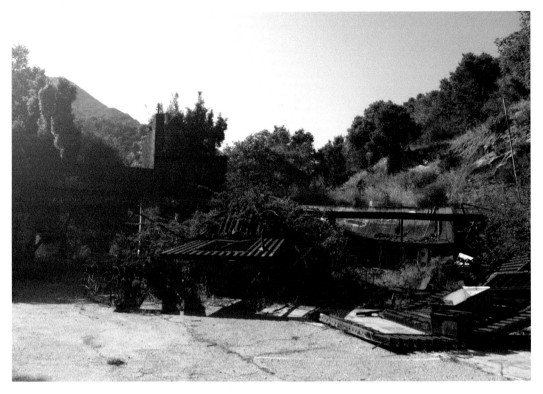

Pacific Palasades [*Rebecca Leib*]

Panorama City [*Alixan Gorman*]

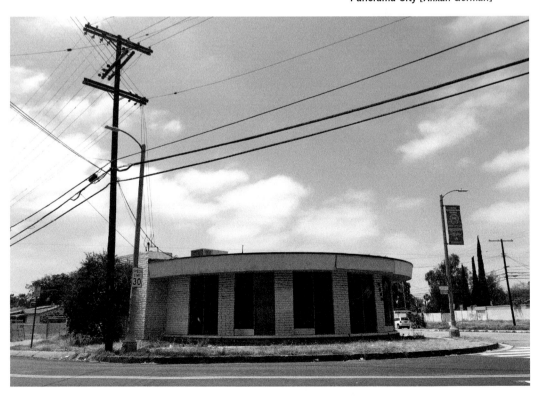

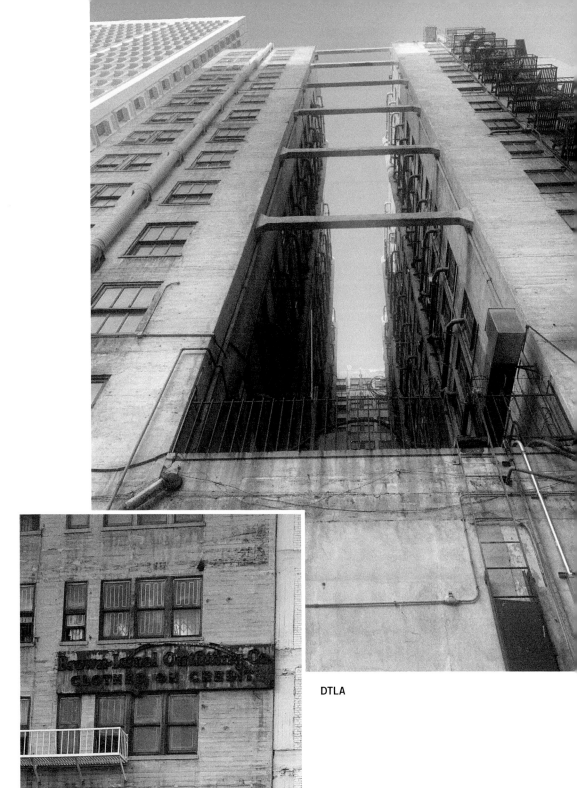

DTLA

43

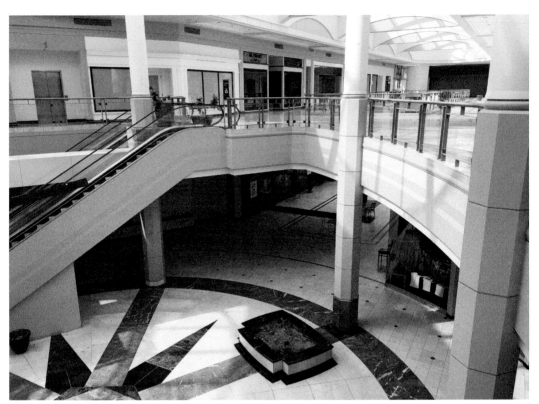

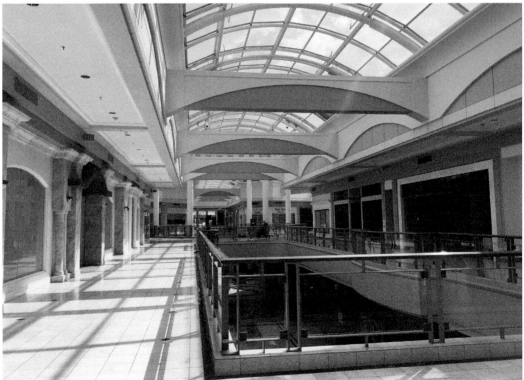

Vacant Promenade Mall, Woodland Hills [*Alixan Gorman*]

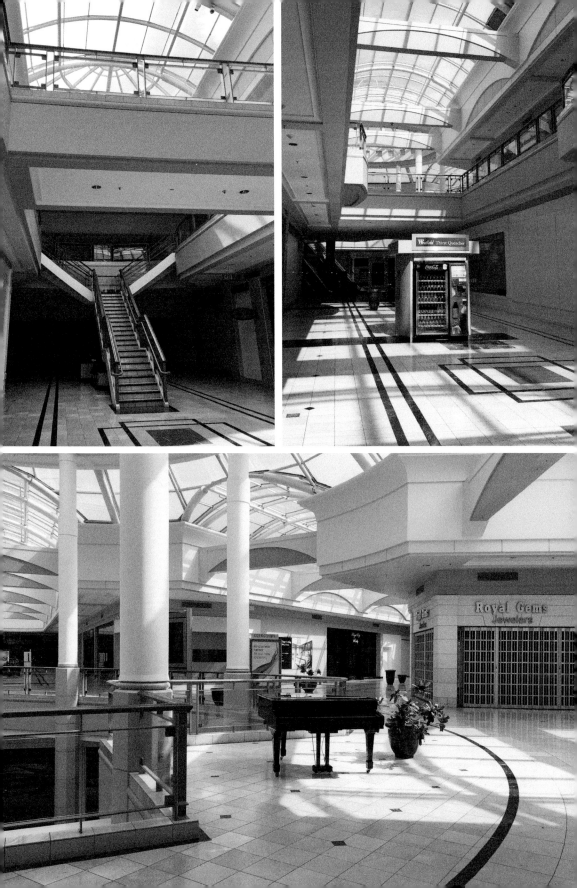

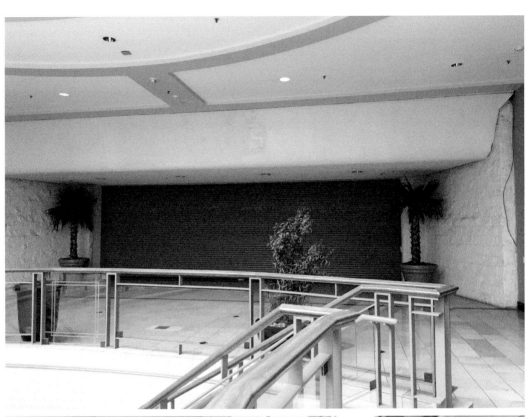

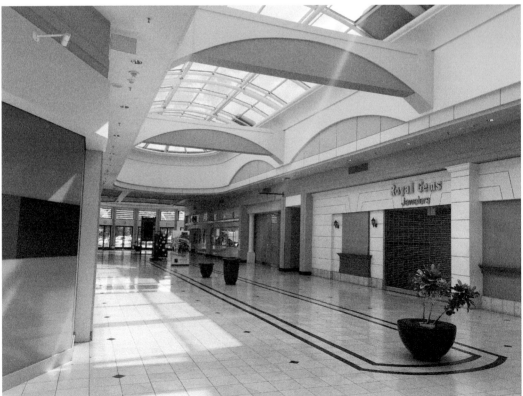

DTLA

Panorama City [*Alixan Gorman*]

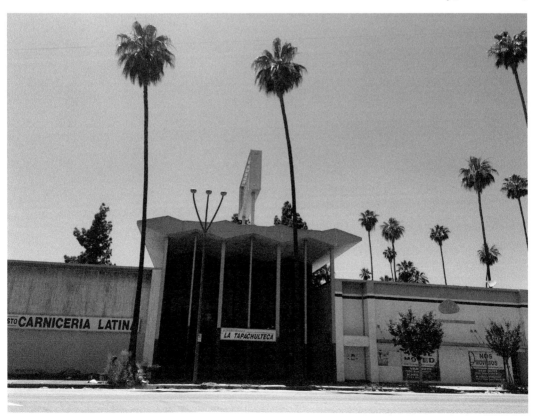

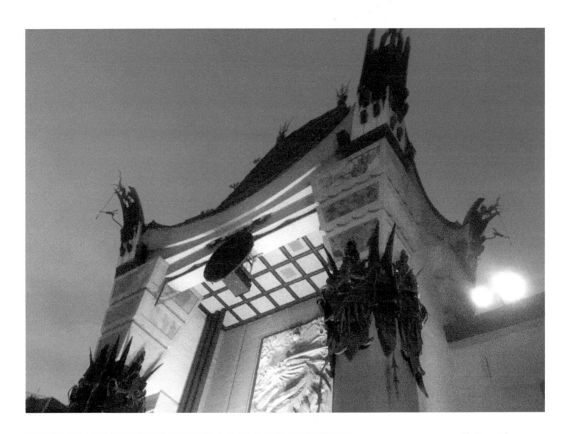

Hollywood
[*Stephan Saffarewich*]

Mighty Mouth, Granada Hills
[*Alixan Gorman*]

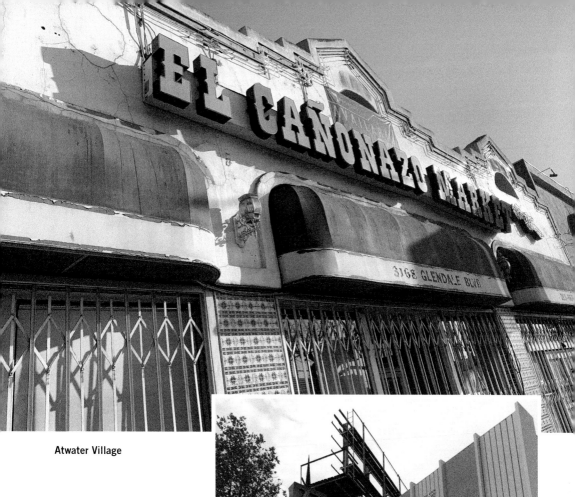

Atwater Village

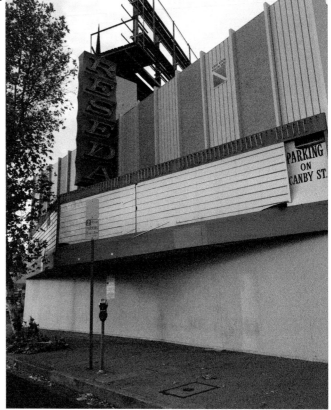

Reseda [*Alixan Gorman*]

49

"Just when you think you've seen it all" is the best way to describe Los Angeles. I have spent most of my natural life living here, and explored so many of its historical pop culture locations that it's mind-bending. Yet, just when you think you've seen it all ...

DANNY BOY O'CONNOR
Cultural Historian, Musician
(Delta Bravo Urban Exploration Team Founder,
Creative Director of The Outsiders House Museum,
La Coka Nostra, House of Pain)

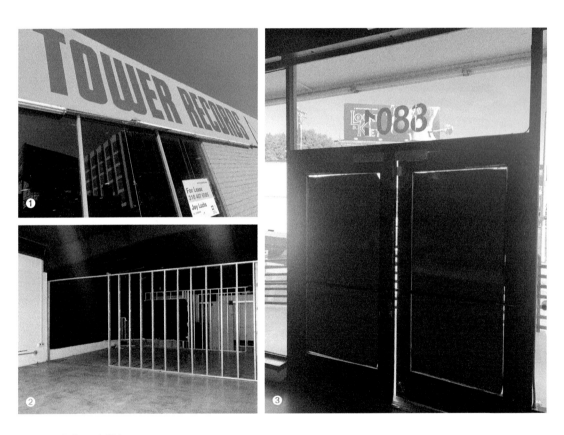

❶ Sunset Strip

❷-❸ Tower Records interior, Sunset Strip

Hollywood [*Stephan Saffarewich*]

DTLA

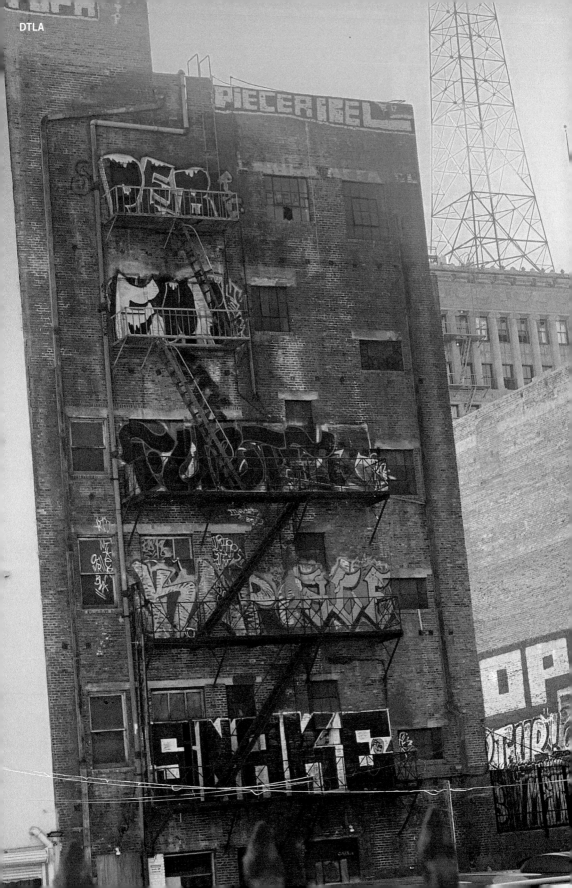

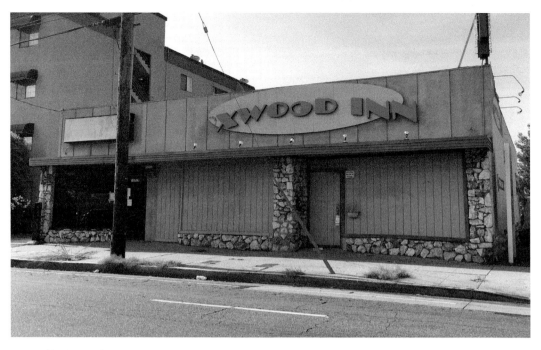

Van Nuys [*Alixan Gorman*]

Oxwood Inn

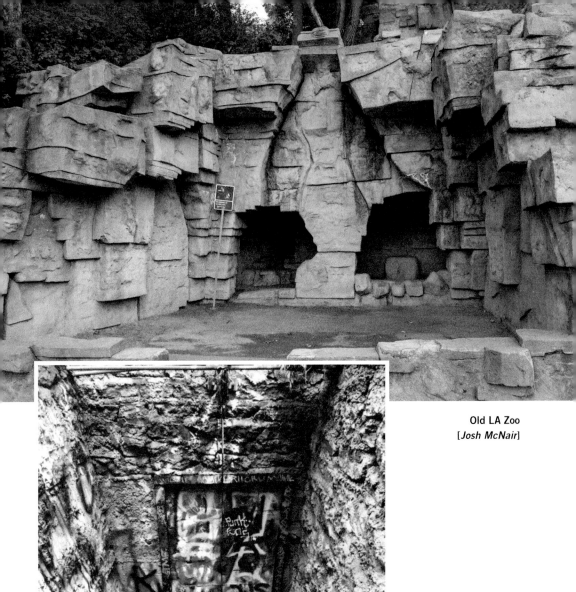

Old LA Zoo
[*Josh McNair*]

Old LA Zoo

There were hundreds of ghosts around my house in the Malibu Hills. You could only hear them when I opened the sliding window in my bedroom. As an experiment, I would take people down there, and then open my window and ask them what they heard. They all said they heard Indians, lots and lots of pissed off Indians. I was a Hollywood transplant and knew nothing, but always thought it strange there was no trace that Indians had ever been there. It was only later I learned that Malibu had been a flourishing Indian settlement and they had been inventors and artists and traders. However, first the Spanish decimated them and then the settlers ... just wiped them off the face of the earth. Someone who grew up in Malibu told me that when the Decker fires happened, which destroyed so many homes, they literally found an Indian burial ground. The houses had been built over their bones.

After that, when I heard their voices, I would stand at the window and tell them how sorry I was. Because I was. We even found a shaman who did a ceremony for them. Eventually the war cries just faded away.

JOSIE COTTON
Artist, Musician (*Valley Girl* Soundtrack)

Van Nuys [*Alixan Gorman*]

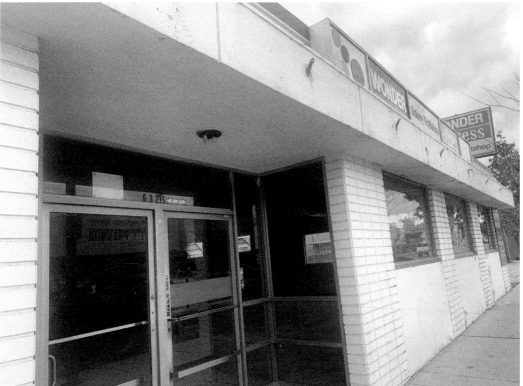

Glendale

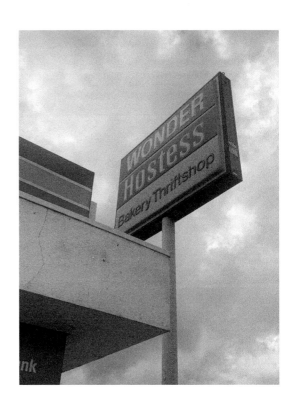

Sun Valley [*Alixan Gorman*]

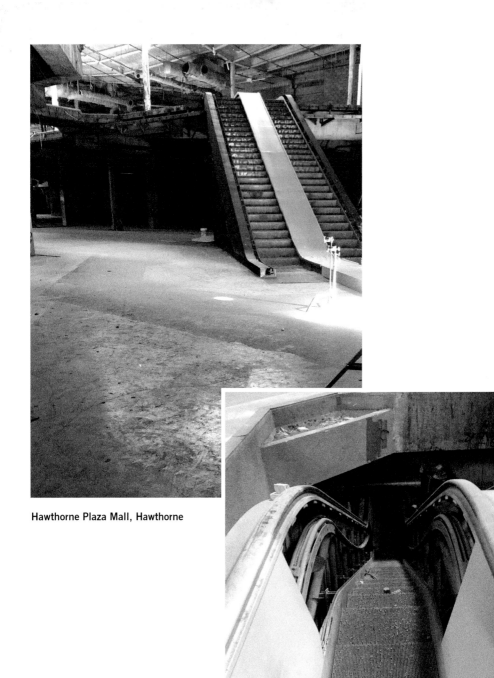

Hawthorne Plaza Mall, Hawthorne

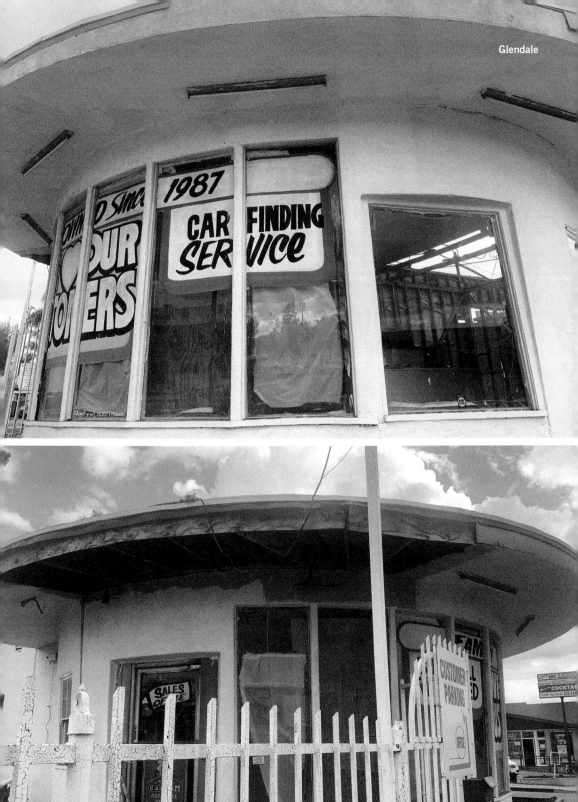

Glendale

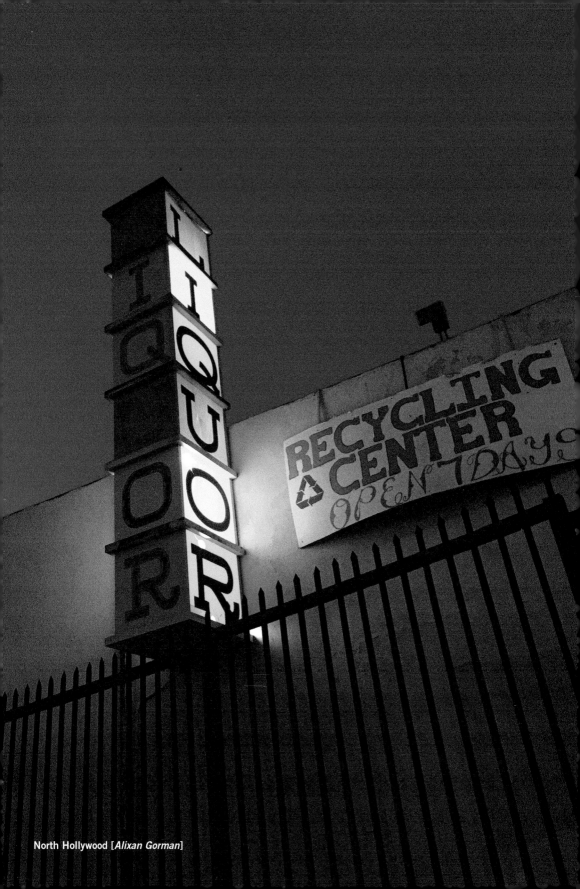

North Hollywood [*Alixan Gorman*]

DTLA

DTLA [*Glenda Smith*]

I moved to LA in August of 2019 and was immediately wicked impressed. It's definitely not like the NYC vibe, but has its own energy. I've been here plenty before touring, etc. I'm gonna be fifty in a month's time and I wouldn't want to be anywhere else for it, to be honest. I started a little band already and it's coming along. This ain't no Boston or NYC by any means, but has its own very specific flavor, and I'm all in.

ERIC KOMST
Musician (Warzone, Sick Of It All)

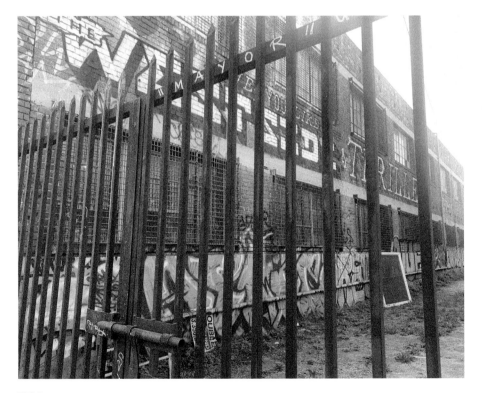

DTLA

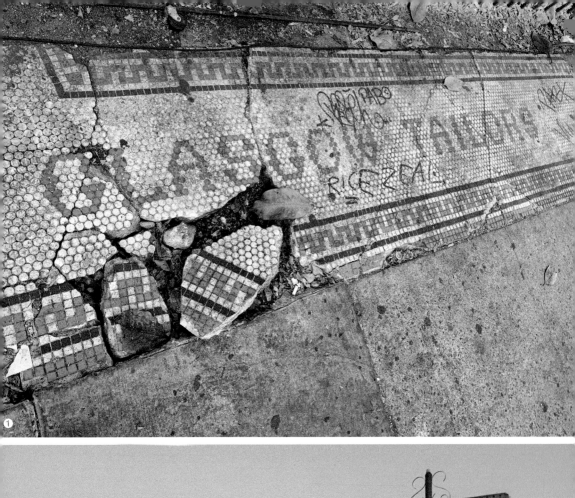

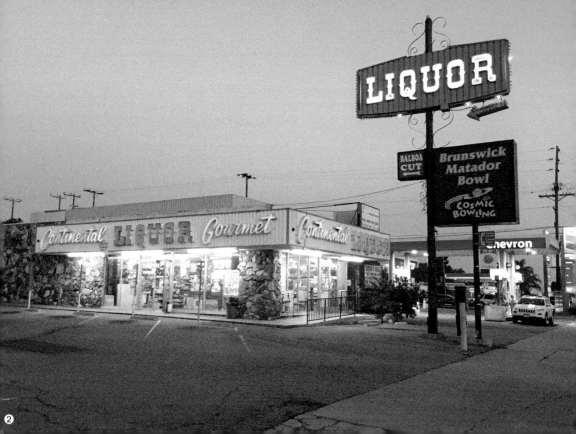

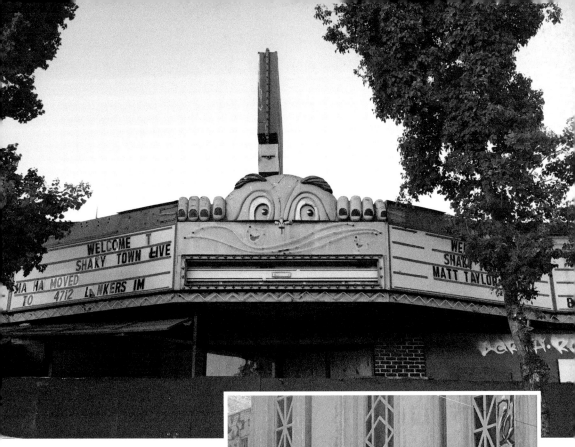

North Hollywood [*Alixan Gorman*]

DTLA

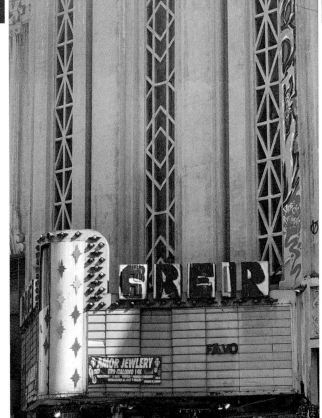

❶ DTLA

❷ Northridge [*Alixan Gorman*]

DTLA

3

HISTORIC

Every place has a history, but there's something about LA that's just different. For such a young city, so much has happened here, defining Los Angeles as a place that is undeniably one of a kind.

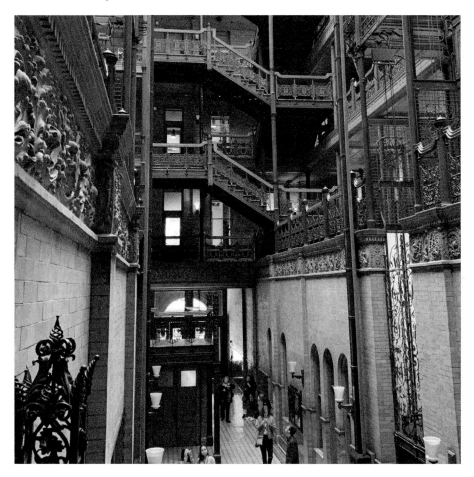

Bradbury Building, DTLA

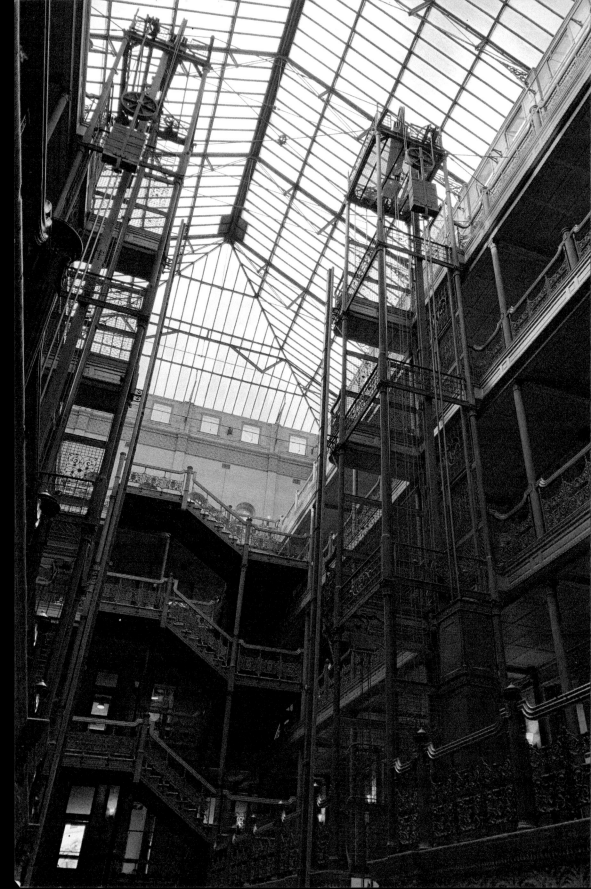

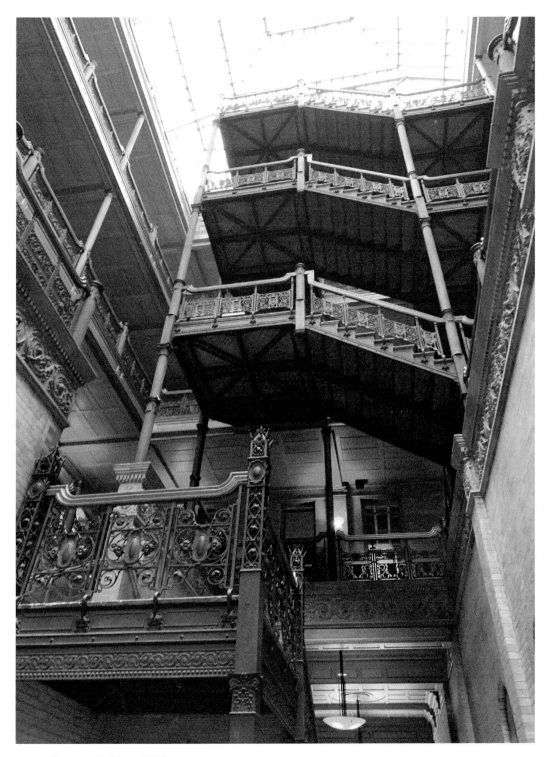

Bradbury Building, DTLA

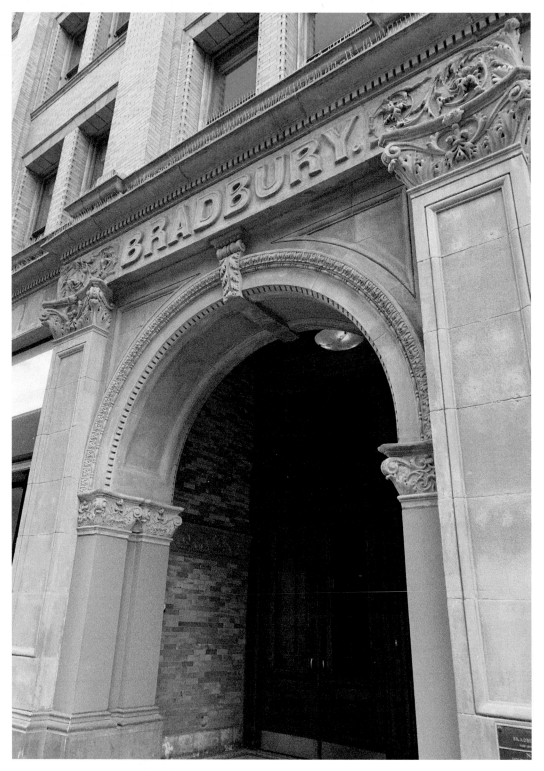

❶ Chinatown [*Alex Millauer*]

❷ Clifton's Cafeteria, DTLA

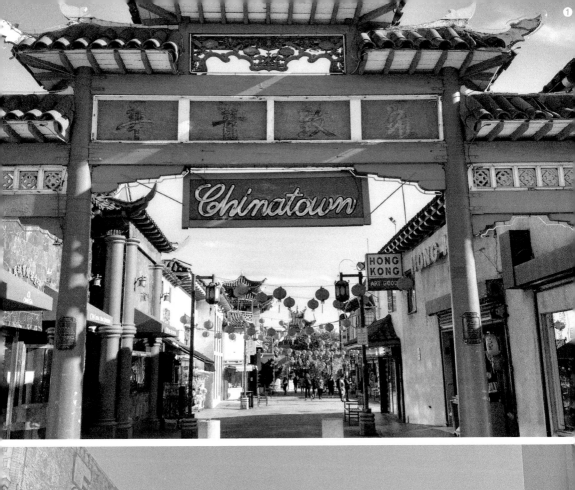

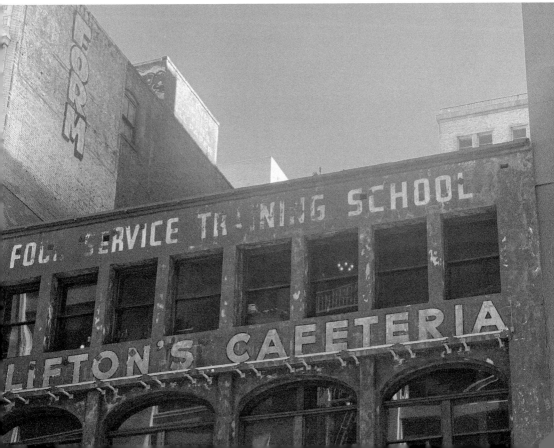

I was born and raised in Texas. Southern Baptist, country music, diesel trucks: Texas. When I graduated college at twenty-three, I moved out to LA to find my way as an actress. Like so many others, I had a passion for acting and a dream of "making it big." Had it not been for that creative passion, I probably would have stayed in Texas forever; lived in Austin and had a lovely life. But I didn't stay, and out on my own in Los Angeles, my first few years were a whirlwind. While there was a lot to love about the city, it never quite felt like home. I missed the thunderstorms and the music and the friendliness from strangers that I had grown accustomed to in Texas. Even when I experienced exciting career success and my life changed, I always had one foot in LA and one foot back home. I always knew, deep down, that I was only here for my career and I had chosen the city out of necessity. But I remember very clearly the day that changed. It was June 26, 2015, and the Supreme Court legalized same-sex marriage.

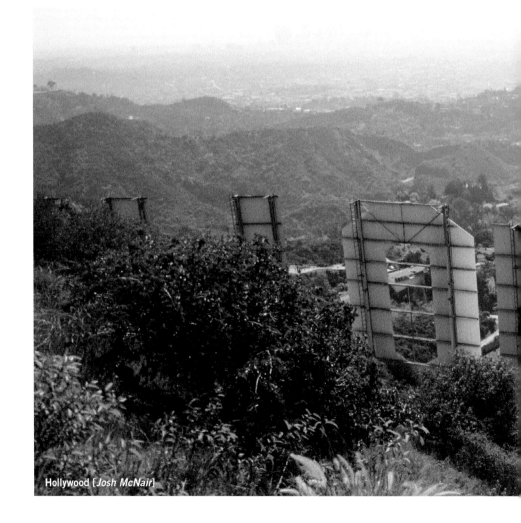

Hollywood [*Josh McNair*]

President Obama lit up the White House with rainbow colors and every single person in Los Angeles seemed happy. As a straight woman, I had never experienced discrimination over who I was allowed to love, but that judgmental mindset was something I often witnessed growing up in a more conservative part of the country. I never understood it.

Walking around my neighborhood in Los Angeles that day, strangers I passed on the street met me with a smile, and there was a sense of community and joy that was palpable. I realized in that moment that while I might have moved to LA because I was an actress, I was staying in LA because these were my people and Los Angeles was my home.

KATIE FEATHERSTON
Actor, Filmmaker (*Paranormal Activity*, *Big Little Lies*)

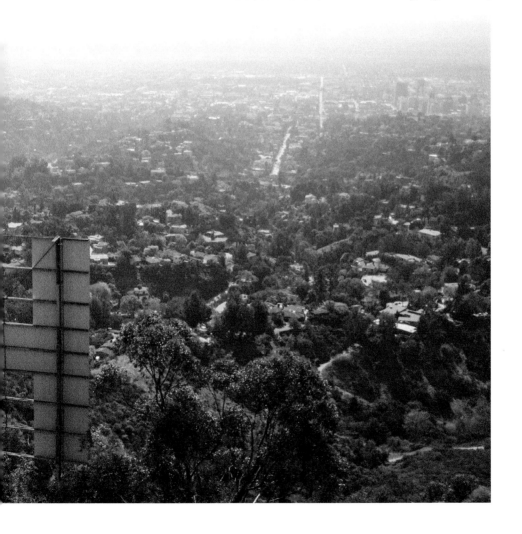

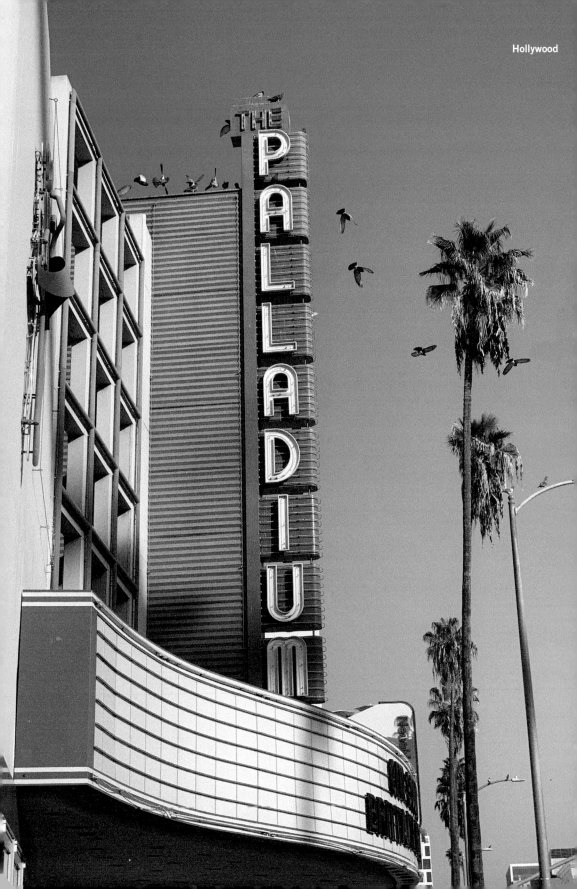

If Seoul, Korea and Oaxaca, Mexico had an urban planning baby: Koreatown!

KRISTINA WONG

Artist, Comedian, Koreatown Neighborhood Council

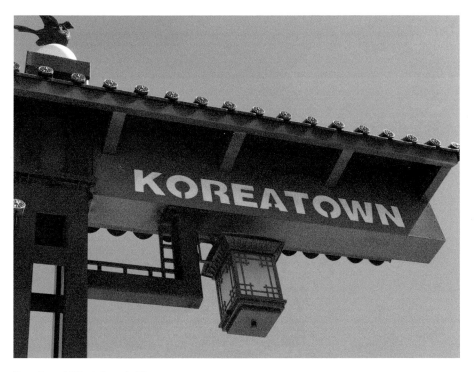

Koreatown [*Albert Campbell*]

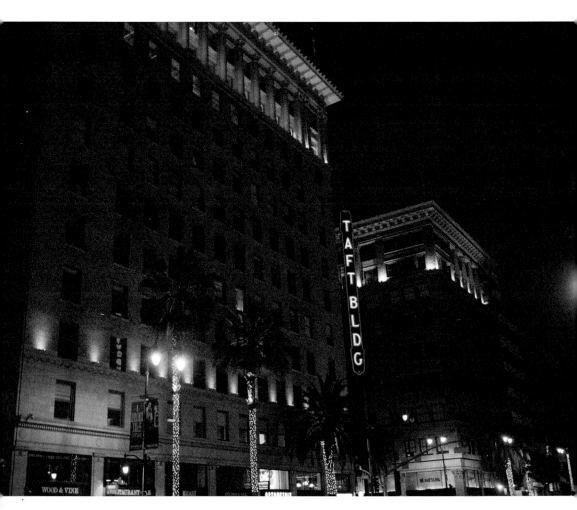

Hollywood [*Stephan Saffarewich*]

Lauren and Hardy's Music Box Steps, Silver Lake

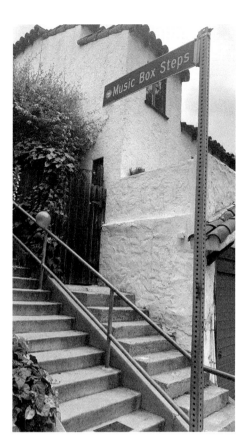

Exposition Park [*Barbara Kalbfleisch*]

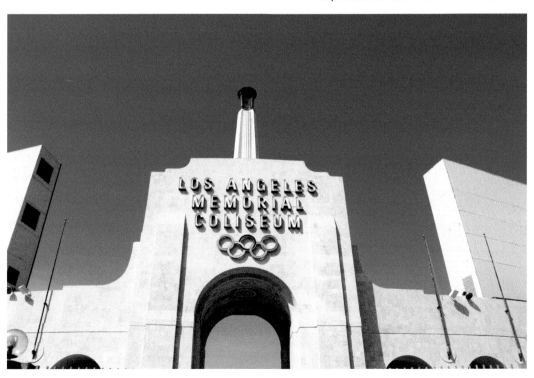

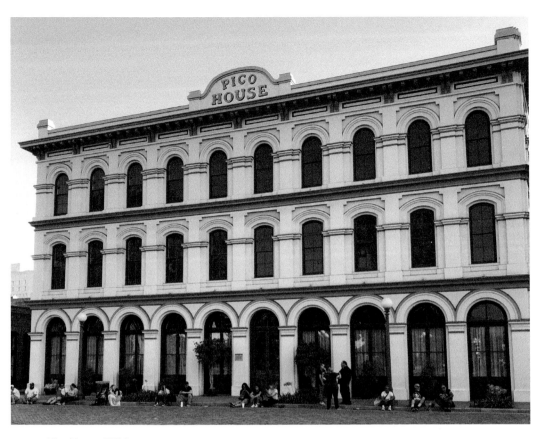

Pico House, DTLA

Olvera Street

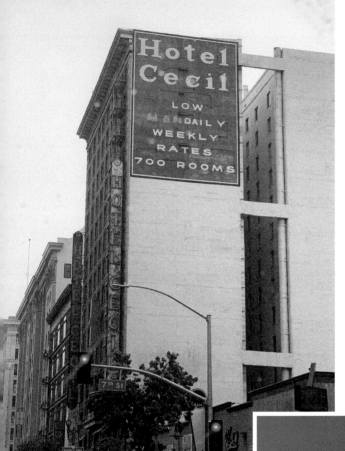

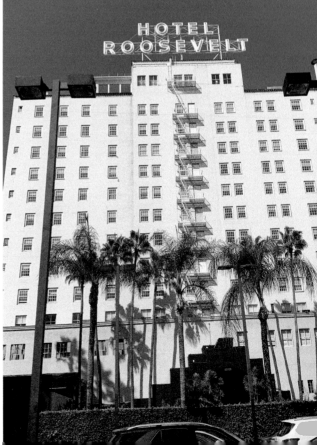

Hollywood

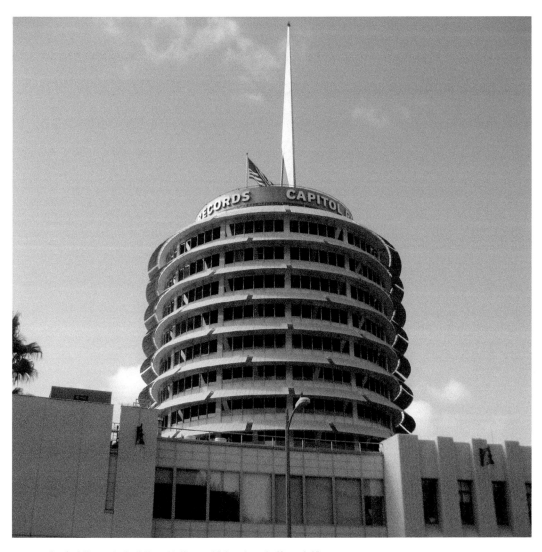

Capitol Records Building, Hollywood [*Stephan Saffarewich*]

I was born and raised in New York City, which is the kind of place millions of people dream about growing up in. It's interesting, because ever since I was a little kid, I had a deep fascination with all things Los Angeles. Don't get me wrong, I feel fortunate to have come of age in what many cultural writers considered the epicenter of cool during the '80s, but throughout it all, my mind often drifted westward. The funny thing is I didn't actually step foot in the Golden State until many years later.

My first trip to Los Angeles came in the '90s when I played bass in a band you never heard of. While most people that visit the city for the first time ask for directions to the Hollywood Sign, my sights were set on a sacred place miles from that tourist trap. Ever since I first read about it in an old issue of the heavy metal rag *Circus* magazine when I was in junior high, I knew I had to find a way to the Rainbow Bar and Grill one day.

The Rainbow (if you ever refer to it with the "Bar and Grill" included, you probably can't name more than two Ratt songs) was founded in 1972, and in a city where restaurants have as much of a chance at success as a sitcom during television pilot season, the fact that it's still packed on any given weekend is something to marvel at. Since moving to Los Angeles in 2006, I've spent many nights eating so-so pizza and downing draft beers with ex-members of Dokken and Pretty Boy Floyd sitting in a booth nearby.

While there are a myriad of reasons why I love the Rainbow, what I find most appealing about the joint is the fact that no matter what year it is, it feels like you've stepped into a time machine that got stuck on "Summer of 1988" and it's totally by design (I think). Hanging out there on a Saturday night transports you to the era when stores across America couldn't keep enough Aqua Net and stonewash denim in stock.

I'm a self-admitted "hair metal" fan, but even if you weren't raised on a steady diet of Headbanger's Ball, there's something so fun about hanging out at a spot where you can think to yourself: "Yep, that's totally the chick from the 'Cherry Pie' video!"

CARLOS RAMIREZ
Writer, Musician (No Echo, Black Army Jacket)

Sunset Strip

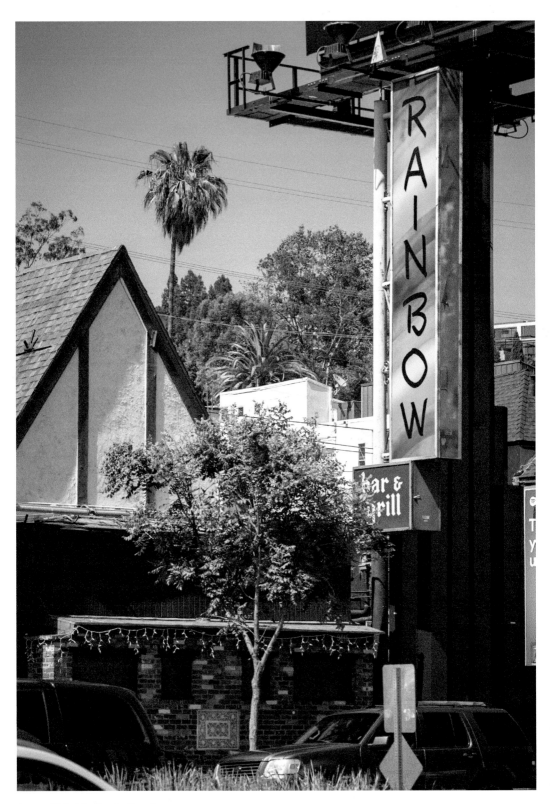

Sunset Strip [*Benjamin Clapp*]

Former Hotel Cecil, DTLA

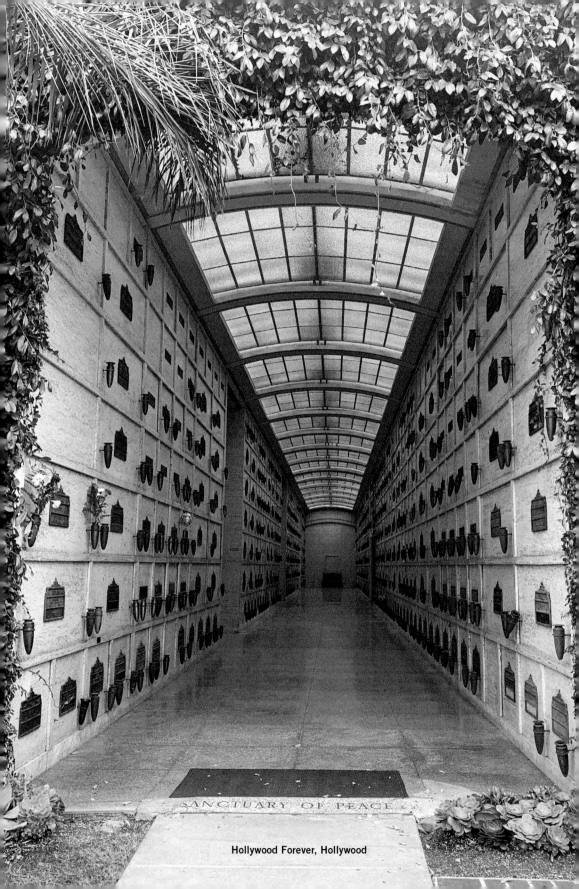

SANCTUARY OF PEACE

Hollywood Forever, Hollywood

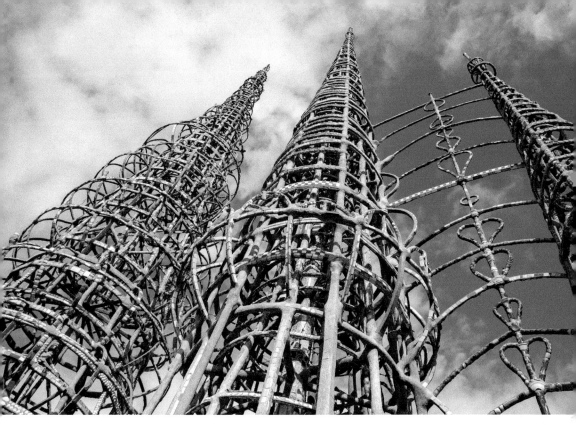

Watts Tower, Watts [*Josh McNair*]

LAX, Inglewood [*Glenda Smith*]

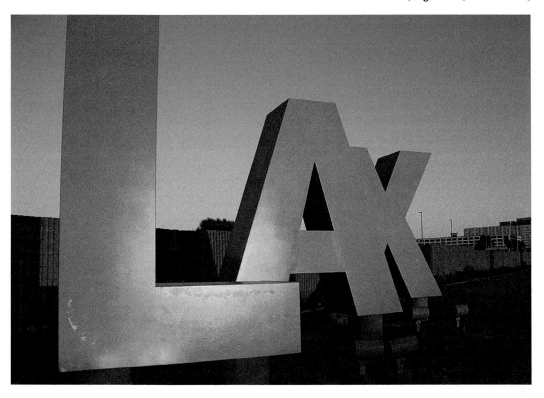

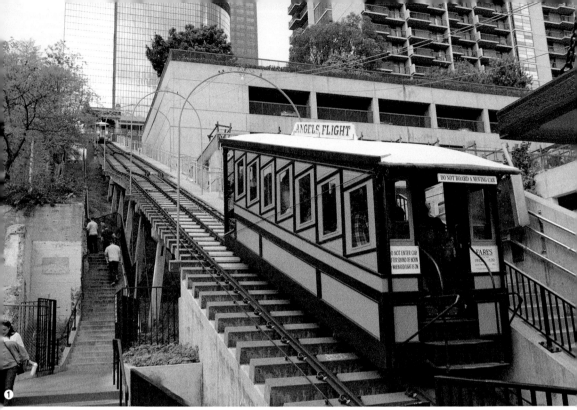

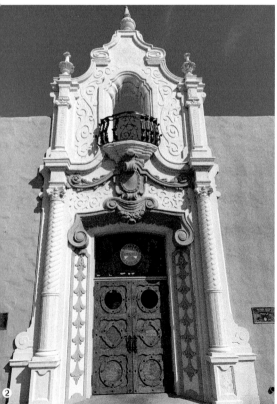

❶ Hollywood [*Stephen Saffarewich*] ❷ Glendale ❸ Olvera Street

I grew up in Thousand Oaks, a small suburb about 20 or so miles north of Los Angeles. I was born in 1975 in Manhattan, but my family moved to Southern California only a few short months after I was born. I was a product of the '80s, and in fifth grade, a friend and I even auditioned for the school talent show with a rendition of "Paul Revere" by the Beastie Boys.

I grew up without cable television, yet I was obsessed with MTV, and I would watch it at my friends' houses any chance that I got. I found punk music in sixth grade, after seeing some band names and logos scrawled across the grip tape of a friend's skateboard. I went to the local Music Plus and scoured the tape wall for anything that aesthetically looked like it might be a punk band.

After finding punk, I was hooked. My parents had recently been divorced and I was splitting time between my mom's house and my dad's condo just a mile or so from each other. My dad's next-door neighbor was older and had an insane collection of punk records. He even played drums in a local garage punk band called Skratch Bongowax. Pre-internet, the only way you could hear classic punk records was if you knew someone who owned them. Thankfully, I now did.

I remember going down to Wherehouse Music and buying an eight-pack of blank TDK cassettes. Dead Kennedy's had released a tape of In God We Trust in 1981 with a B-Side that stated "Home taping is killing record industry profits! We left this side blank so you can help."

Every weekend I would borrow two or three records at a time and bring them home to dub them on my Sony dual-cassette turntable. I don't think anyone's profits were harmed, because most of these dusty records were long out of print, and just waiting to be unearthed, dusted off, and discovered by a new generation of kids just like me.

I started attending Thousand Oaks High School in 1989, a school whose most famous alumni at that time were Michael Richards, who played Cosmo Kramer on Seinfeld, and Paul Watkins, a member of the Manson Family who later testified against Charles Manson and clarified the Helter Skelter motive (not surprisingly, he dropped out his senior year). I quickly made friends with the only other kid at my school into hardcore and we started going to shows.

My first real punk show was in January of 1990 at the Country Club in Reseda, in the San Fernando Valley. It was Circle Jerks with NOFX and a bunch of really bad bands, but that didn't matter. My life was about to be changed by finally seeing a band who had records I had listened to over and over again in my bedroom, live on stage.

I quite literally dove right in (see what I did there?).

You wouldn't expect a small suburb of the Valley made famous by the Karate Kid to be the epicenter for punk and hardcore, but for a time it was. Every weekend, we would hop into an older friend's car and take the 101 South, exit Reseda Blvd, drive

past Captain Ed's Smoke Shop and the strip mall with the 7-11 and Thai Pot (a local Thai Restaurant that had what looked like a pot leaf as a logo), up to Sherman Way to where the Country Club was located (less than a mile away from the South Seas Apartments where the fictional Daniel Larusso lived with his mom).

The scene was not yet divided, or oversaturated with bands playing all over the city every night of the week, and when there was a show (except for the random Monday night shows), everyone came out: punks, skins, hardcore kids, goths, headbangers, skaters, and more. I would not say the "kids were united," but if you were actively involved in one of these subcultures you would go to every show that you could.

For a few short years, this was our stomping grounds. Seeing bands like Bad Religion, Insted, MDC, Infest, Chain of Strength, Walk Proud, Excel, Social Justice, Visual Discrimination, Judge, and Gorilla Biscuits was life-affirming for us.

The point of this story isn't just to take a walk down memory lane, wax nostalgic about my musical heroes, or to simply try to relive my glory days of youth. What I am trying to say is you should celebrate what you have before it is gone.

I never thought music venues like the Country Club, Anti-Club, Fender's, and Showcase Theatre would ever close. Yet, it is the same fate Green Hell, Aaron's, Bleeker Bob's, and Zed Records—all pivotal music retail shops in my punk rock education—would ultimately succumb to.

Blame economics, blame the internet, blame whatever you might, but though those venues and record stores are all but a memory now, the mark they all left on me is profound.

Henry Rollins said it best: "Youth is fleeting and life is short, you might as well strike hard. Anything else is just average"

ANDREW KLINE
Musician, Record Label Owner
(Strife, World Be Free, Berthold City, War Records)

Hollywood Forever

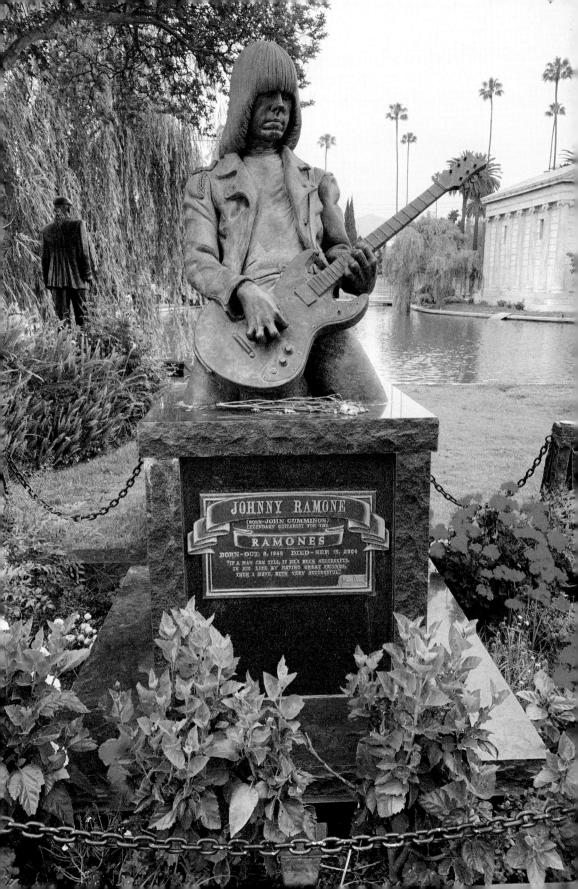

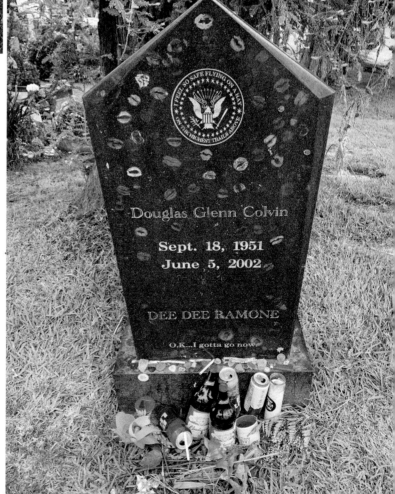

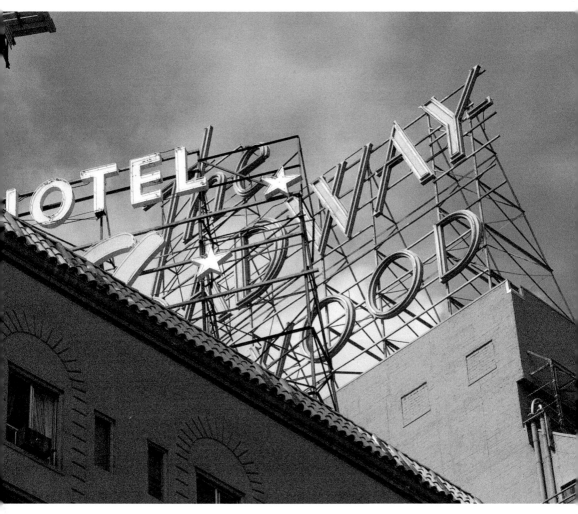

Hollywood [*Stephen Saffarewich*]

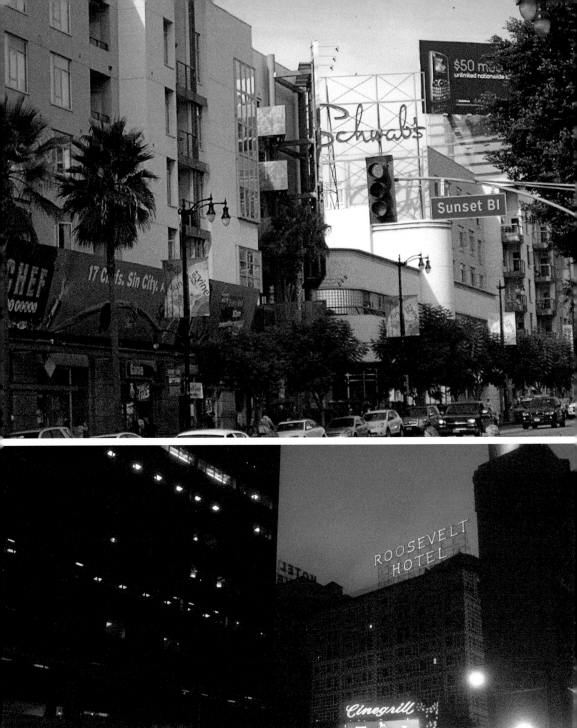
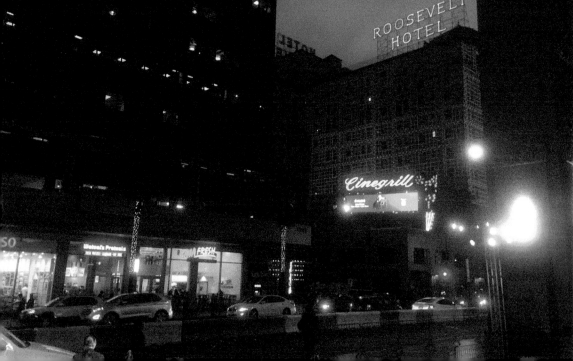

To say that the Beastie Boys made a huge impact on music and lives is an under-statement. Perhaps it's less "changing" music and lives, and more like "shaking it violently." At least it was for me. Their album *License to Ill* was—and in a lot of ways still is—a game changer. At thirteen I didn't know what "partying" was, or that I had a constitutional right to do it. What I did know was that society was standing in the way from me, and whatever was happening in their "Fight for Your Right" music video. It was rebellious, snotty, and most importantly, loud. It turned out to be my gateway drug to punk, hardcore, and metal. I tried to shoplift the *License to Ill* record. Not the cassette, the record. I wanted to *live* the opening track "Rhymin & Stealin." At least I thought that's what my new three best friends would have wanted. I recall the time I was at an arcade somewhere in New Jersey with with my father. I was proudly sporting a very new, and probably very tucked in, Beastie Boys t-shirt. In between endless rounds of Galaga, I was approached by a shady, yet ultra-cool stranger. He asked if I wanted to buy two tickets to the Beastie Boys/Run DMC Together Forever tour. My dad said no (typical establishment). Totally understandable. Fast forward to what must have been my late teens or early twenties, a girl told me I looked like the Beastie Boys. Which one? Never bothered to ask. Didn't need to. It made my night/week/year. Another quick jaunt in time takes me to Lollapalooza '94, solely to see Beastie Boys. Looking back, I like to pretend Rick Rubin himself tried to sell me those tickets all those years before.

To me, the Beastie Boys *were* New York City. If you would have told me, or I suppose if the Internet existed, that back in the late 80s and early 90s the Beastie Boys recorded some of *Ill Communication* and *Hello Nasty*, and all of *Check Your Head* in Los Angeles, I would have felt betrayed. When I found out that their record studio was in Atwater Village, where I happen to live, I was floored, humbled, and honored. Back in the day I would watch a VHS compilation of the Beasties music videos, which included the one for "Netty's Girl," located at Echo Park Lake. Echo Park didn't exist for me back then. Now, it is very much part of my LA experience. The Beastie Boys legend covers Los Angeles, especially the Eastside. I never, and I mean never, walk down Glendale Boulevard, which is where I currently am right at this moment, without thinking of Ad Rock, Mike D, and MCA.

JASON HORTON

RIP MCA

Former G-Son Studios (top floor),
Atwater Village

EL PUEBLO GIFTMART